P♥RN FOR women

P♥RN (FOR) *women*

CHRONICLE BOOKS
SAN FRANCISCO

FROM THE CAMBRIDGE WOMEN'S PORNOGRAPHY COOPERATIVE

PHOTOGRAPHS BY SUSAN ANDERSON

Cover photo courtesy of Getty Images, Inc.

Library of Congress Cataloging-in-Publication Data available.

ISBN-10: 0-8118-5551-1
ISBN-13: 978-0-8118-5551-8

Photographer's assistants: Joe Budd and Brian Slaughter
Styling: Micah Bishop, Artist Untied
Hair styling: Travis Michael Jennings and Stacey Miller
Models: Rich Fonseca, Michael Hernandez, Adrian Madlener,
and Joe Tyson, all from Look Model Agency

The photographer would like to thank:
Deborah Ayerst, Artists' Agent, for creating this opportunity.
Scott Idleman for his Eichler house and hospitality. Micah
Bishop at Artist Untied. Al at Look Models for great-looking
men with a sense of humor. Joe Budd and Brian Slaughter for
their hard work. Jodi Davis and Kate Prouty at Chronicle Books
for their creative input and great taste. Men everywhere for
inspiring women.

Designed by Stella Lai
Manufactured in China

Distributed in Canada by Raincoast Books
9050 Shaughnessy Street
Vancouver, British Columbia V6P 6E5

10 9 8 7 6 5 4 3 2

Chronicle Books LLC
680 Second Street
San Francisco, California 94107

www.chroniclebooks.com

What really turns women on?

We, at the Cambridge Women's Pornography Cooperative, have dedicated our careers to answering this very question.

In pursuit of answers, we canvassed the nation, traveling far and wide, surveying women across the land. We asked young women, old women, rich and poor, **"what really, really gets you hot?"** Armed with our findings, we then locked ourselves in the CWPC laboratories and worked day and night to create *Porn for Women*—porn unlike any porn you've seen before. It's so **provocative**, so **incendiary**, that we advise each of our readers to find a safe place to sit down before opening these pages.

Prepare to enter our **fantasy world**, girls (or guys who want to learn something): a world where clothes get folded just so, delicious dinners await us at home, and flatulence is just *not that funny*.

– Cambridge Women's Pornography Cooperative

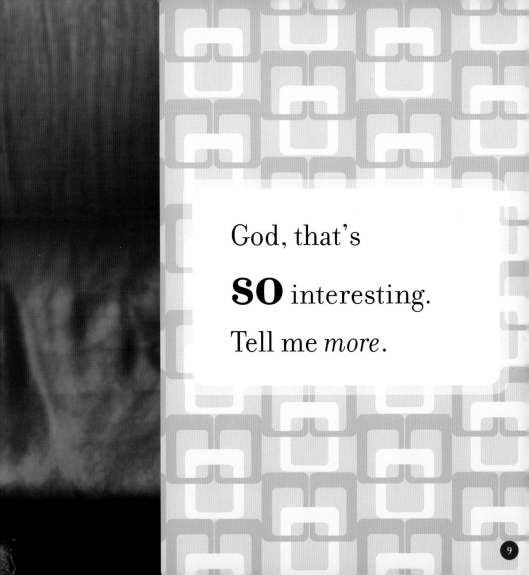

God, that's

SO interesting.

Tell me *more*.

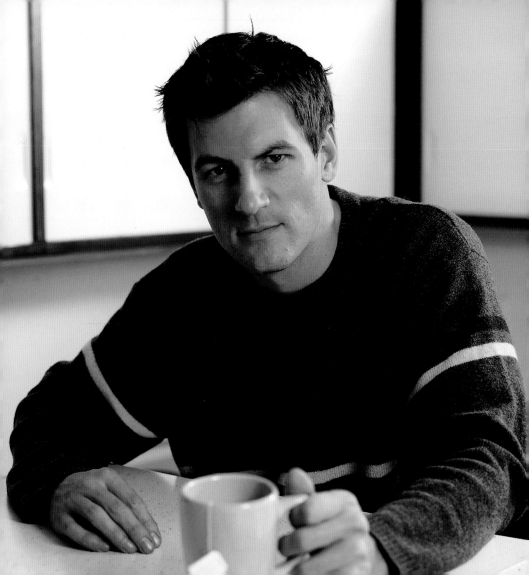

You look stressed.
Let me make you some tea
and we can talk about it.

Chamomile OK?

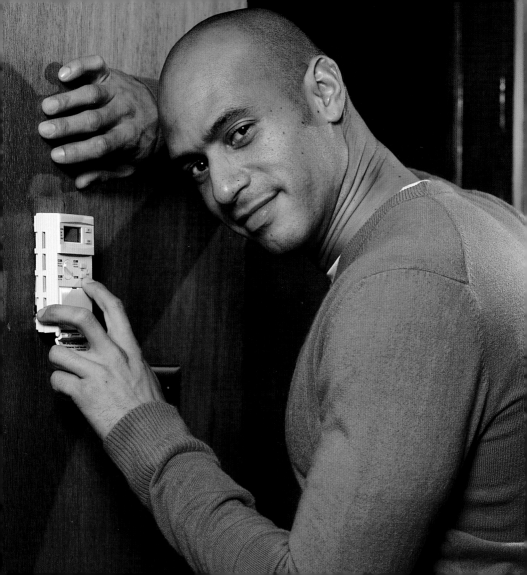

Let's keep the heat set permanently on **"tropical."**

I don't have to
have a reason to
bring you flowers.

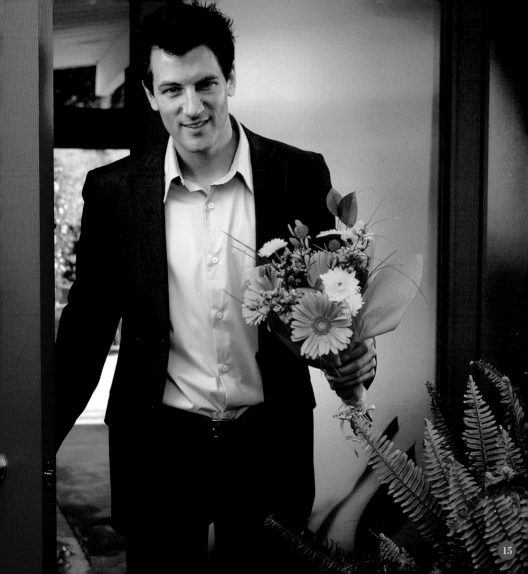

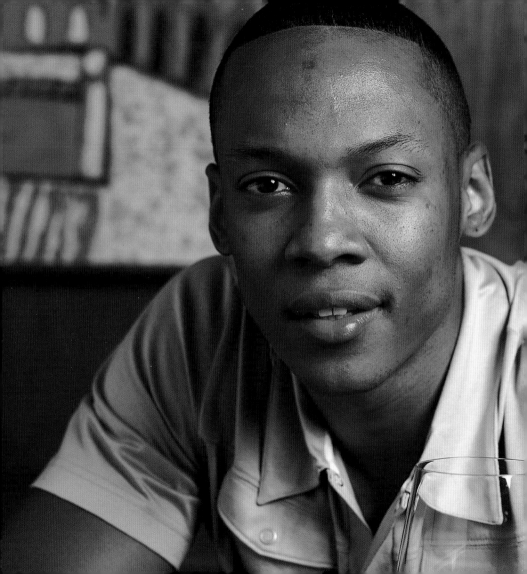

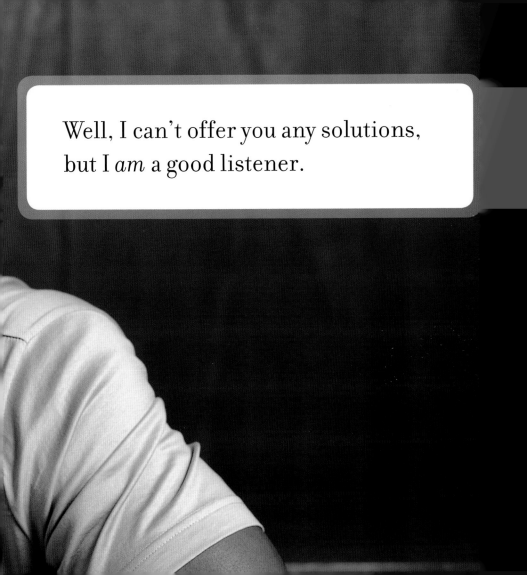

I LOVE
what you've done
with your hair today.

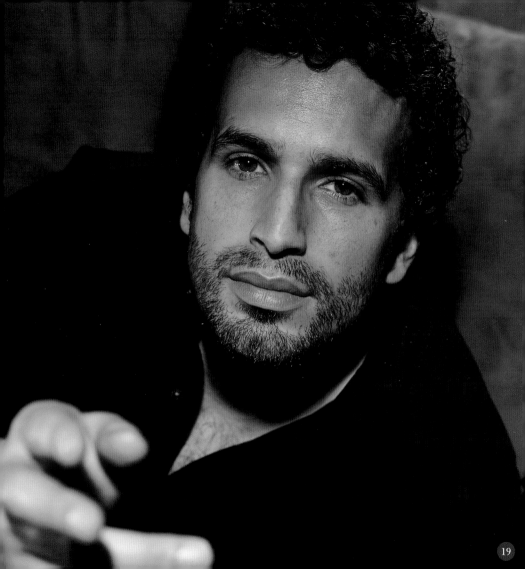

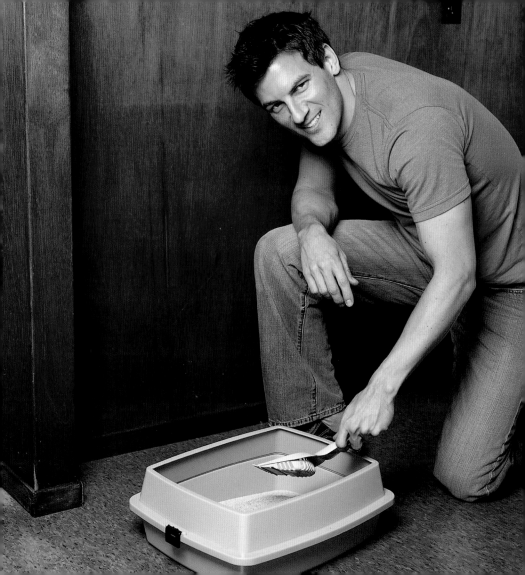

Who could object
to cleaning up after
the cutest thing on four legs?

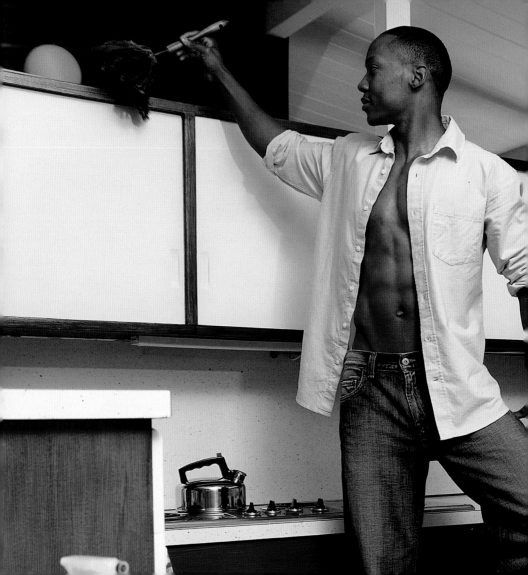

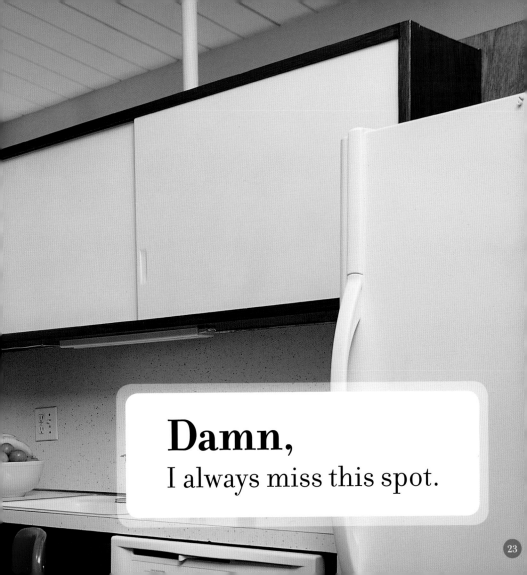

Damn,
I always miss this spot.

I made some
Niman Ranch lamb tenderloin
with garlic, black pepper,
and Indonesian
soy sauce for dinner.
I hope that sounds OK.

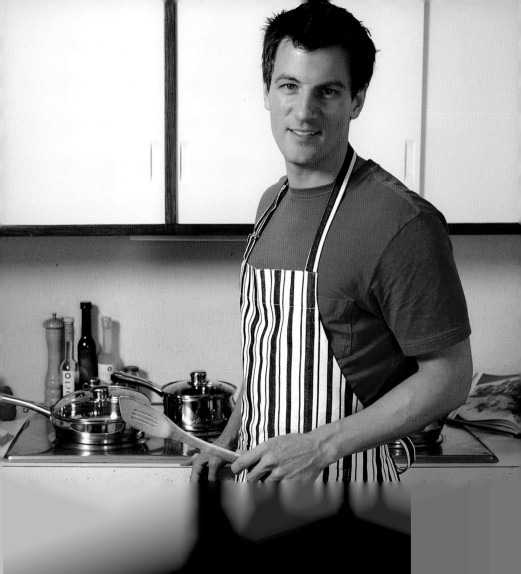

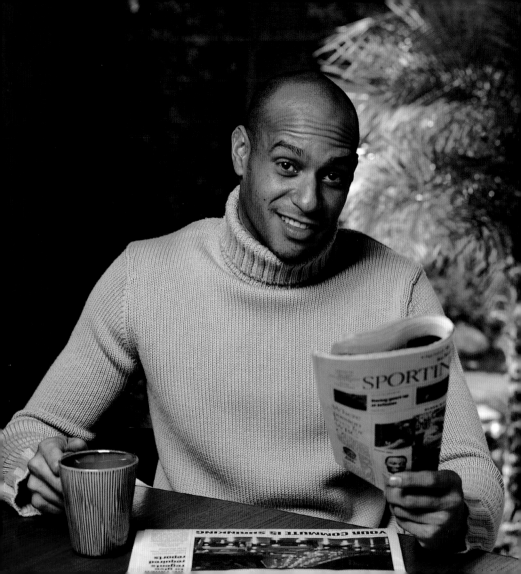

Ooh, look,

the NFL playoffs are today. I bet we'll have *no* trouble parking at the crafts fair.

Why don't I get a minivan, hon,
so **you** can drive something fun?

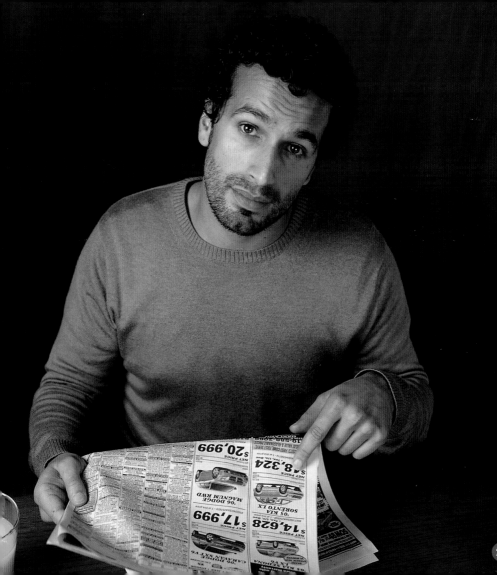

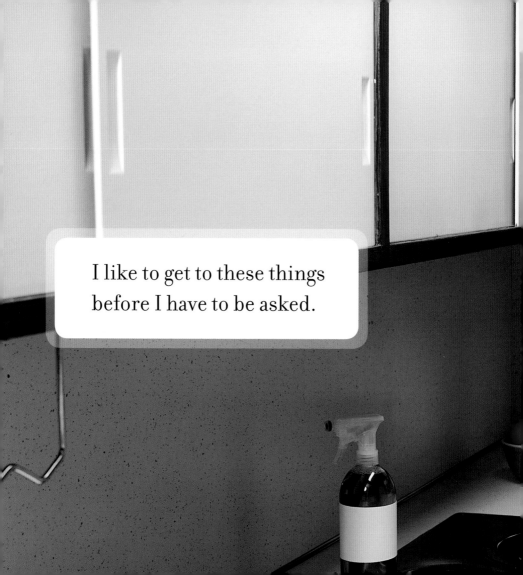

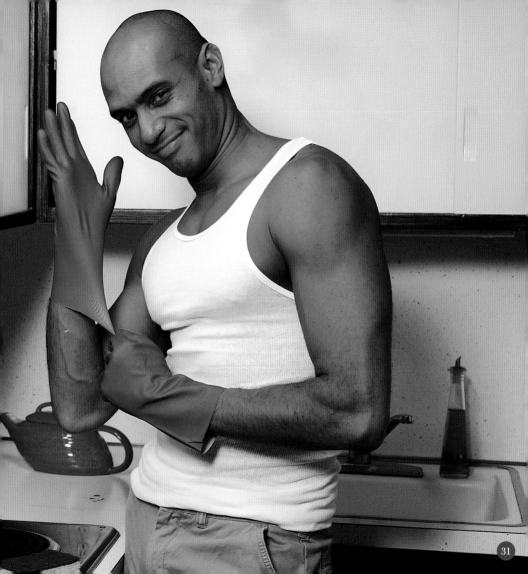

I wouldn't **dream** of letting you do **this job**.

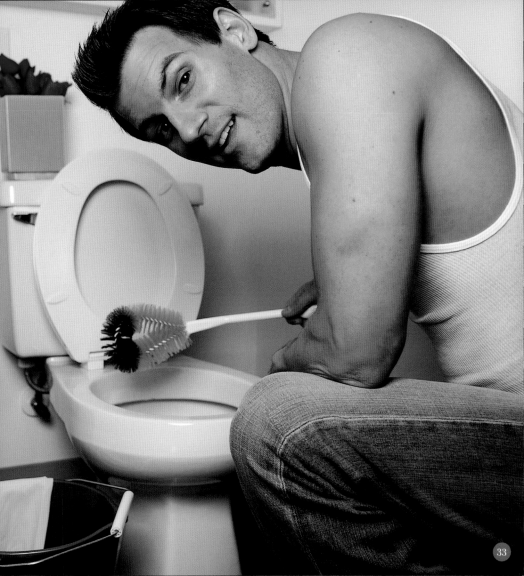

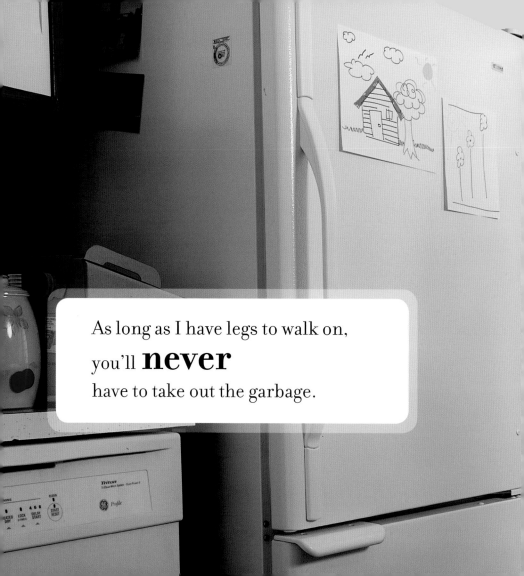

As long as I have legs to walk on, you'll **never** have to take out the garbage.

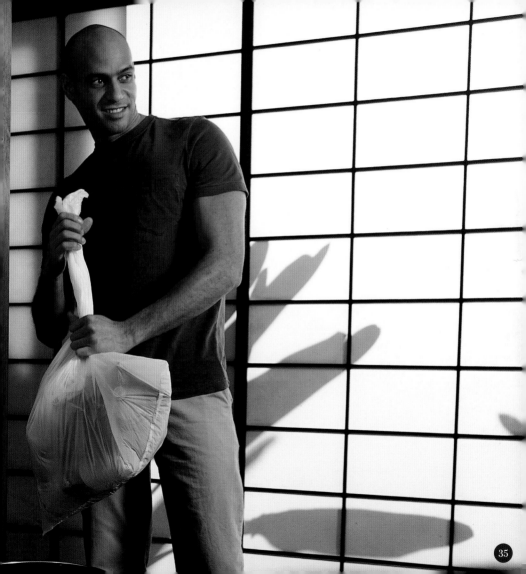

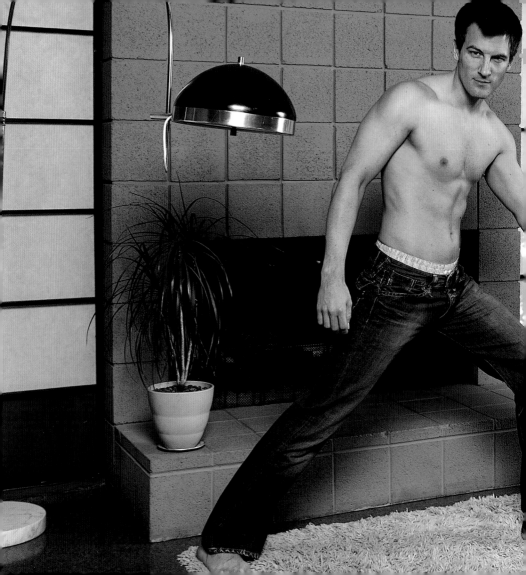

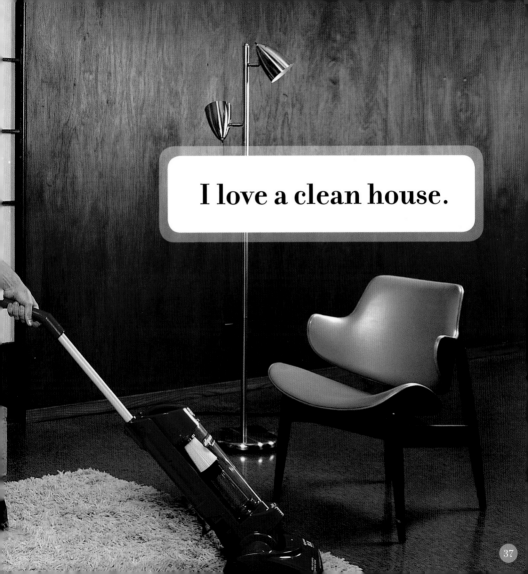

I love a clean house.

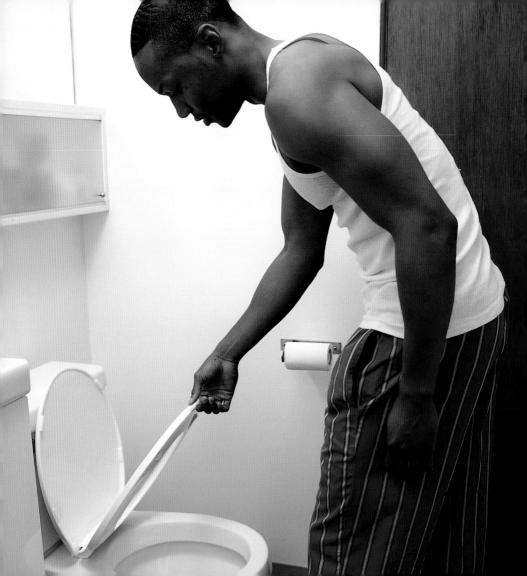

Don't want anyone
"falling in"
in the middle of the night.

Just because I'm married doesn't mean that I shouldn't take care of myself.

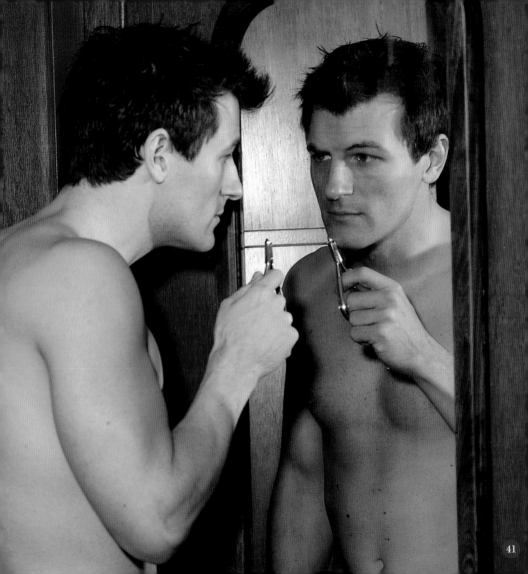

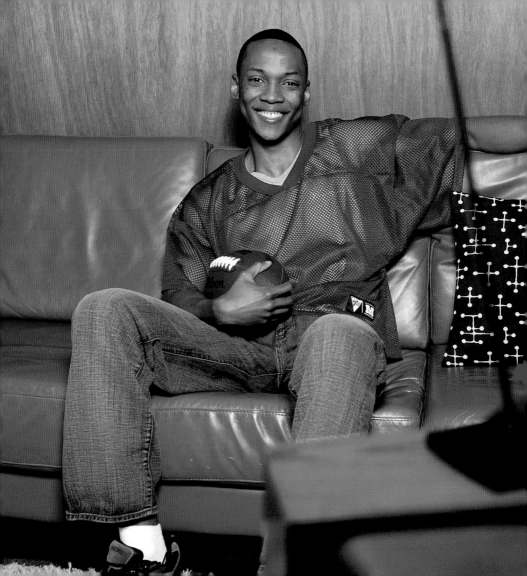

C'mon, sit down!

There are ballgames on all the time. But how often can we watch the figure skating finals?

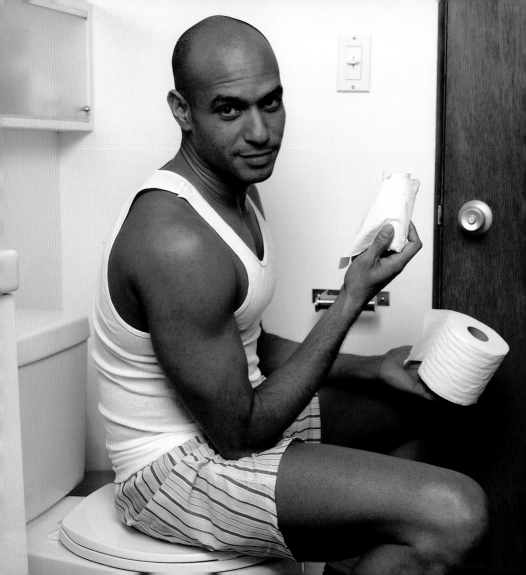

There are only a few sheets left…
I'd better change it now.

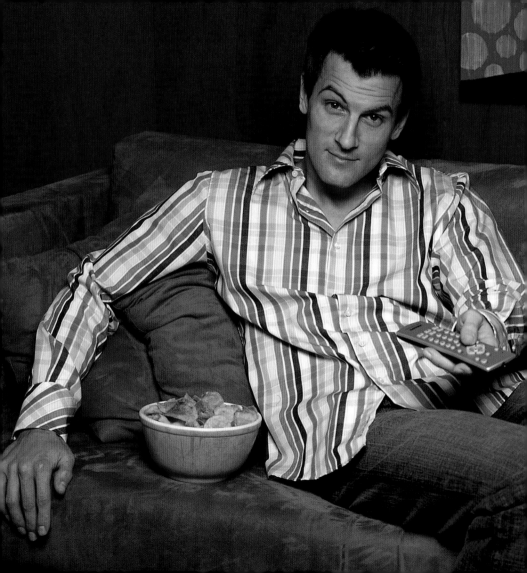

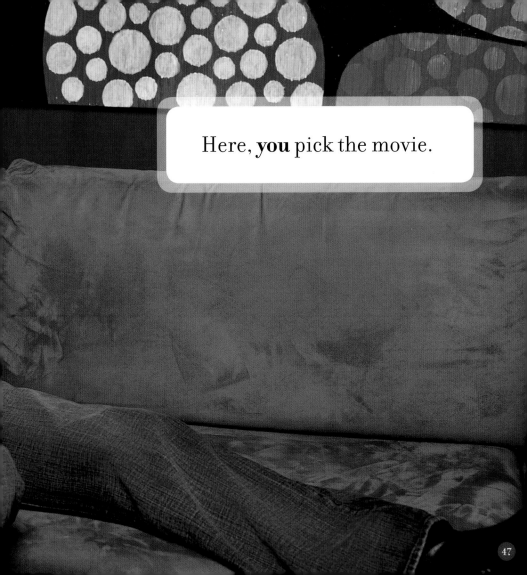

Here, **you** pick the movie.

I know.
Let's take you
shoe shopping!

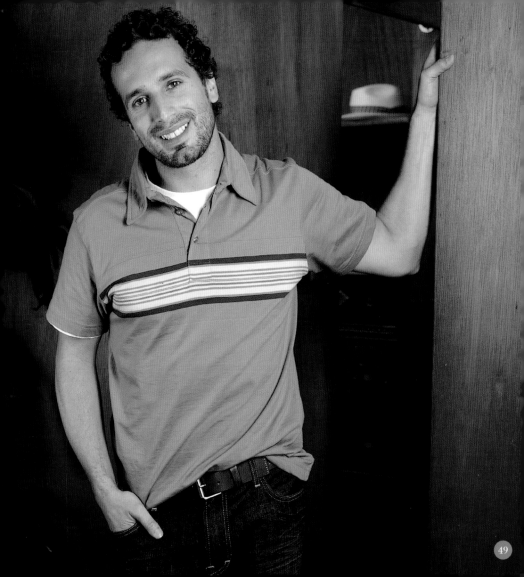

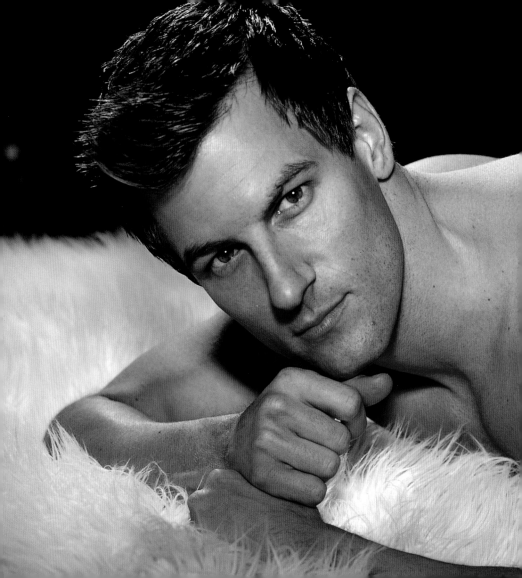

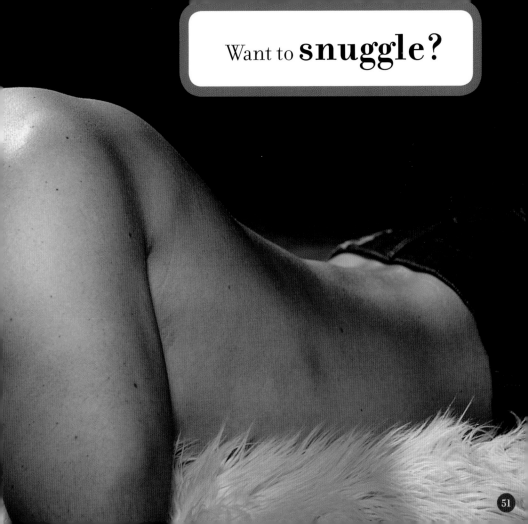

Want to **snuggle?**

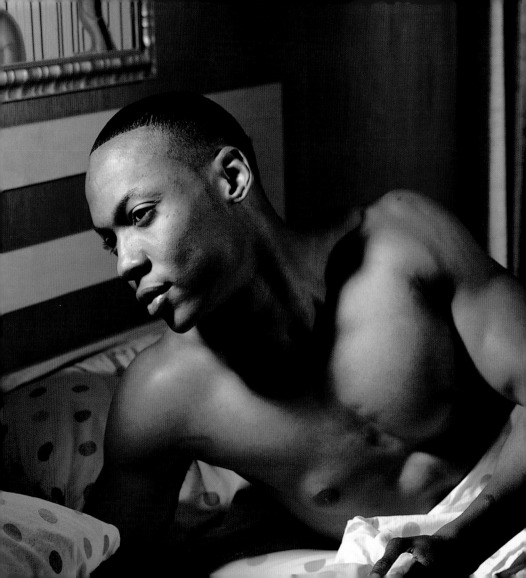

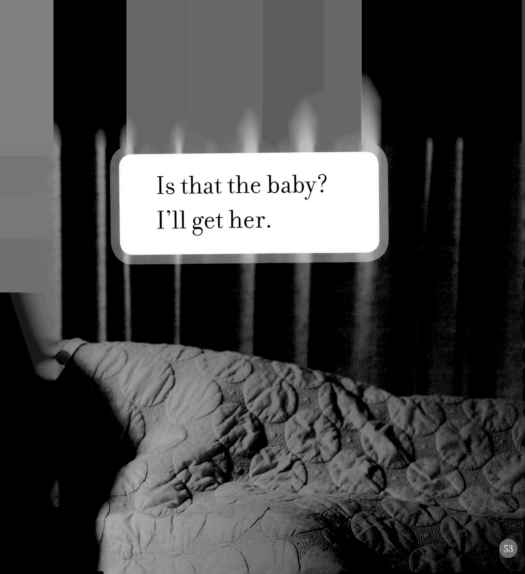

Is that the baby?
I'll get her.

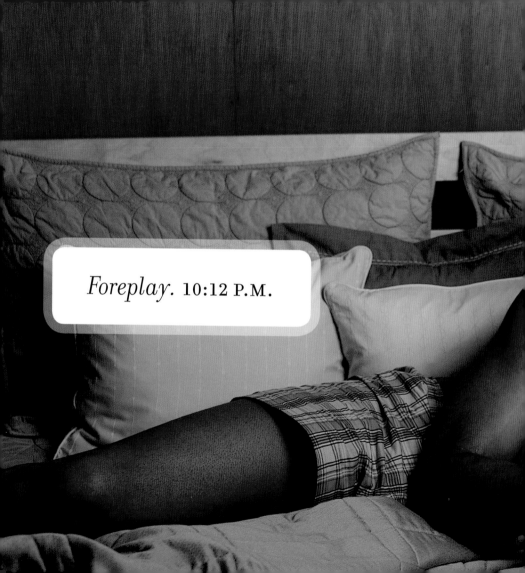

Foreplay. 10:12 P.M.

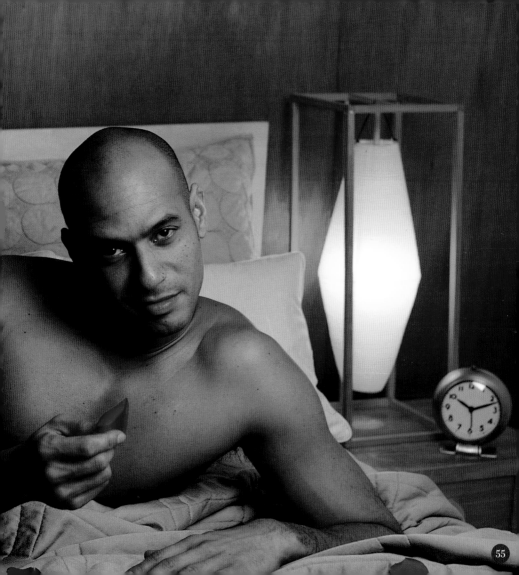

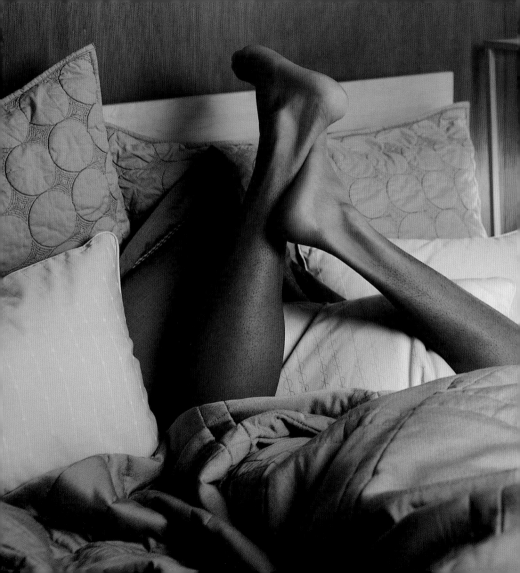

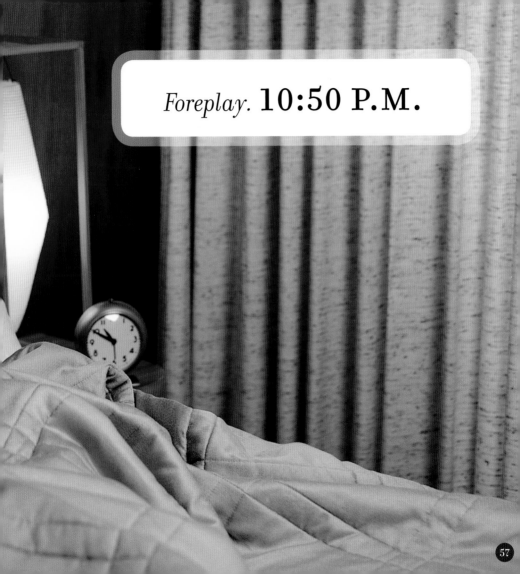

Foreplay. **10:50 P.M.**

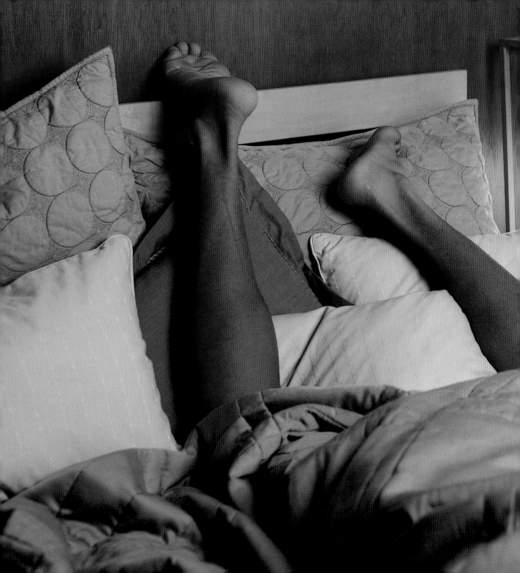

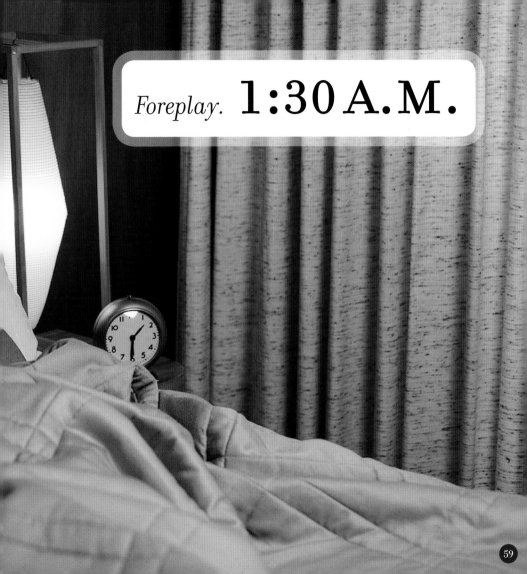

Foreplay. **1:30 A.M.**

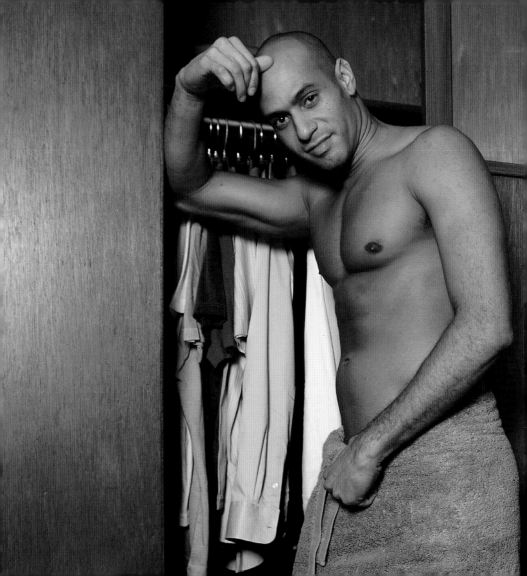

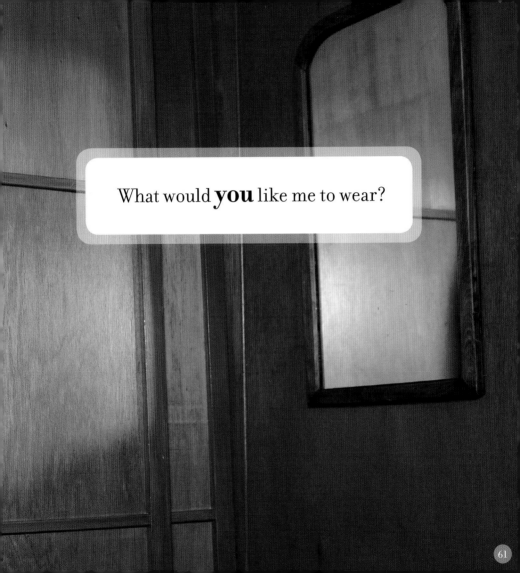

What would **you** like me to wear?

How 'bout
a nice, long
massage?

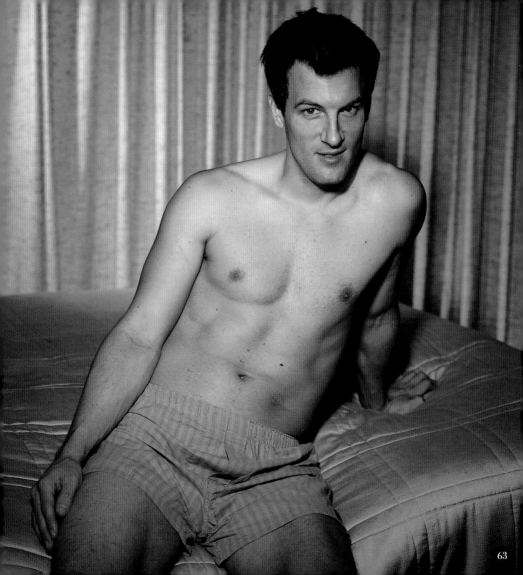

This is the way **you like** the shirts folded, right?

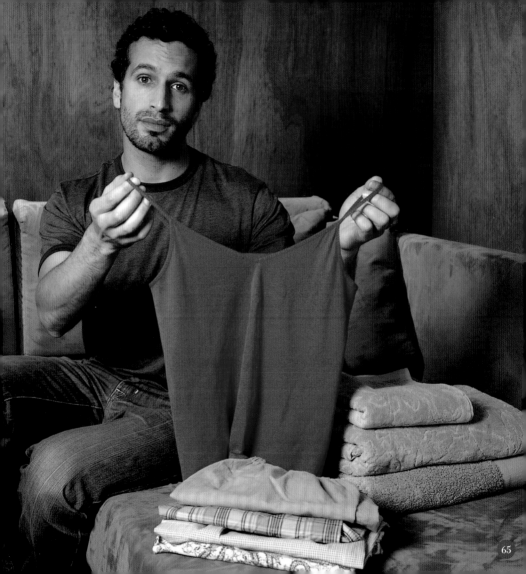

Have another piece of cake. I don't like **you looking so thin**.

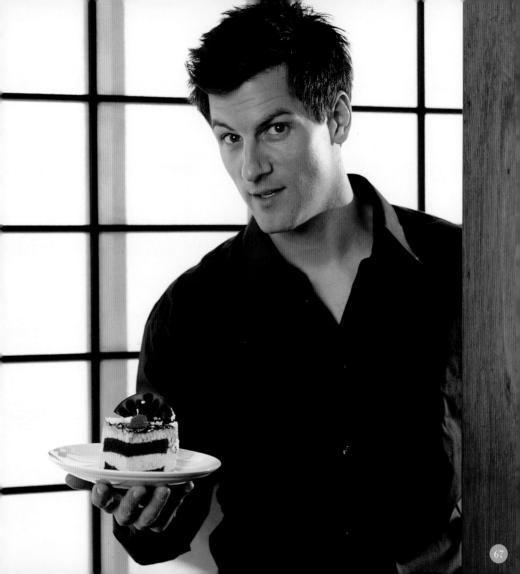

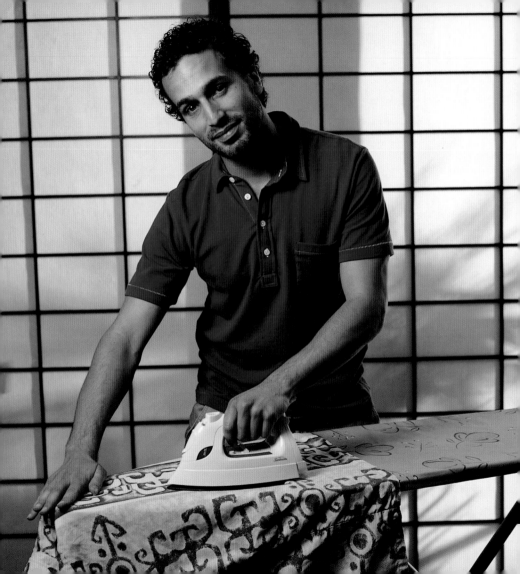

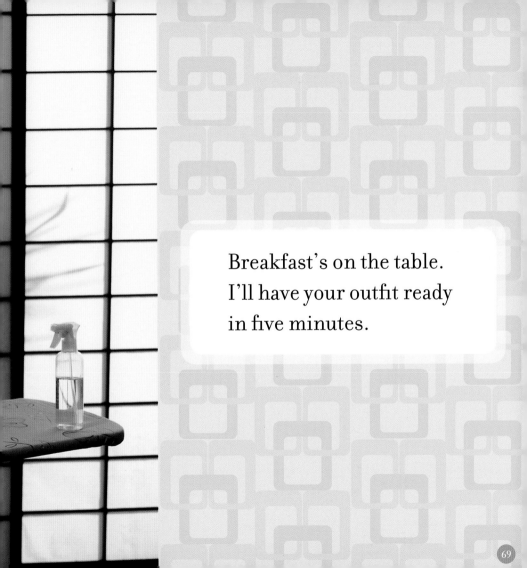

Breakfast's on the table.
I'll have your outfit ready
in five minutes.

Why don't we
invite your mother over
this weekend?

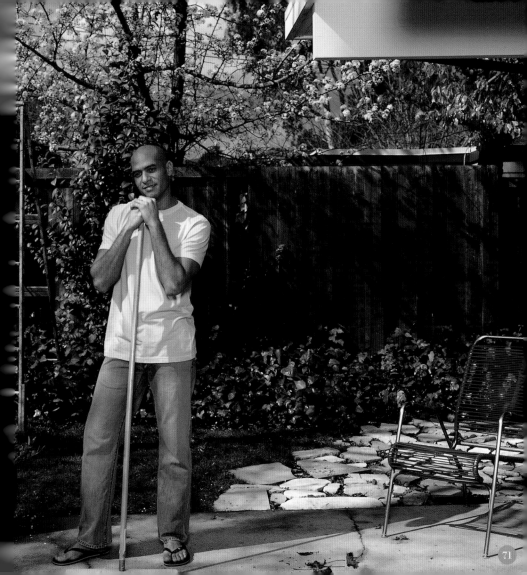

As soon as I finish the laundry,
I'll do the grocery shopping.
And I'll take the kids with me
so you can relax.

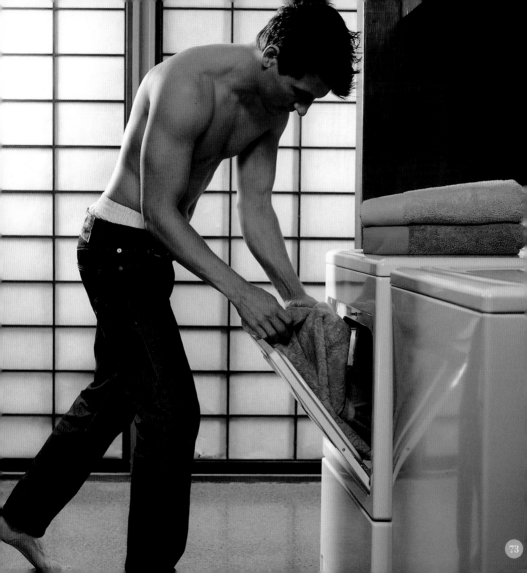

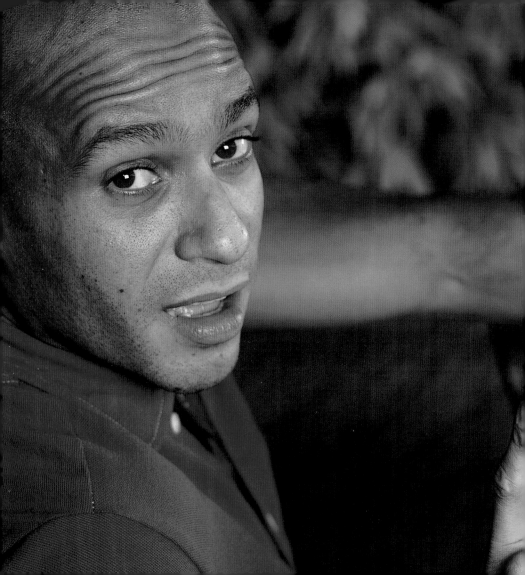

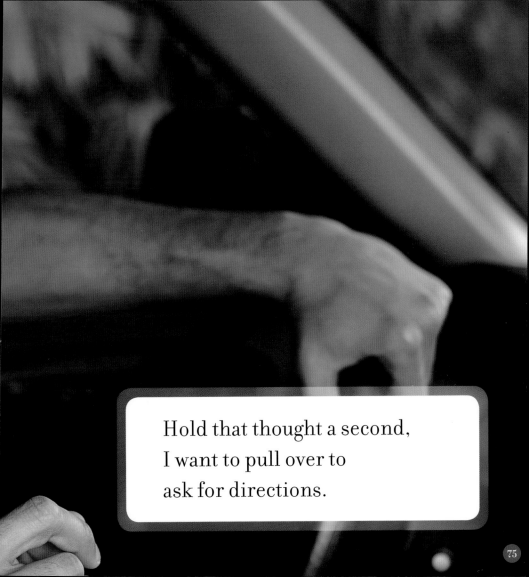

Hold that thought a second,
I want to pull over to
ask for directions.

I just want to be sure we always have

chocolate

in the house.

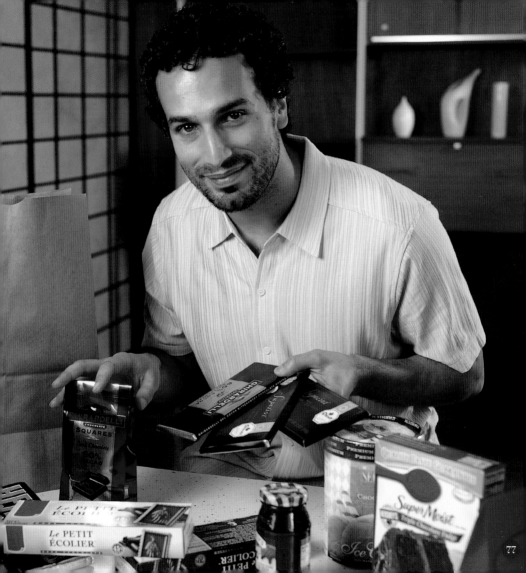

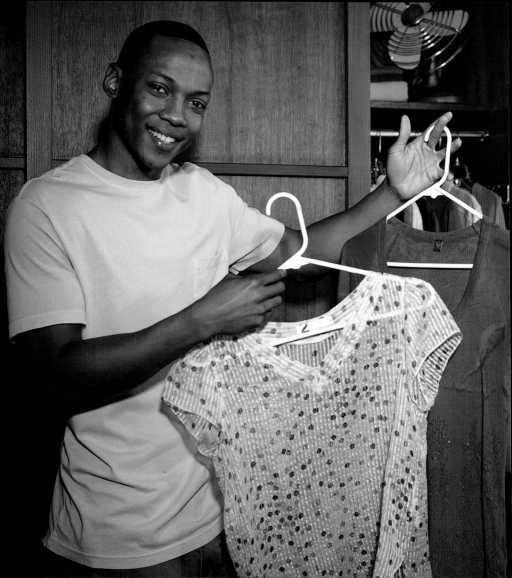

Try these on, hon.
I want to see all the colors on you
before I give an opinion.

Meet the Men

Name	Adrian Madlener
Age	31
Career	Retired dot-com company founder, now funding and setting up world's first "luxury orphanage"
Hobbies	Jazz saxophone, giving massages
Admire	Johnny Depp

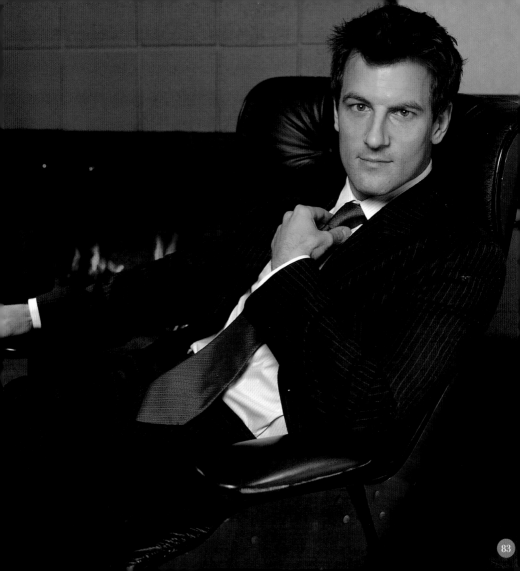

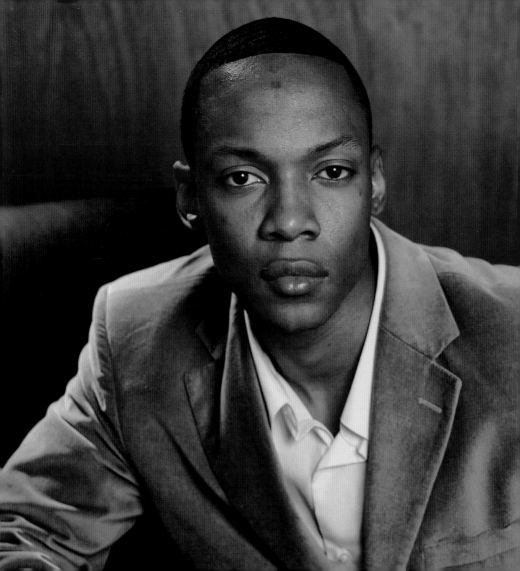

Name	Joe Tyson
Age	29
Career	Globe-trotting archeologist
Hobbies	Big Brother volunteer
Last Book Read	Good Couple, Great Marriage by Robert Mark Alter, noted couples counselor
Admire	Mahatma Gandhi

Name *Rich Fonseca*

Age **34**

Career *Chief of pediatrics at*

major hospital

Hobbies *Bikram yoga instructor,*

shiatsu massage

Admire *Alan Alda*

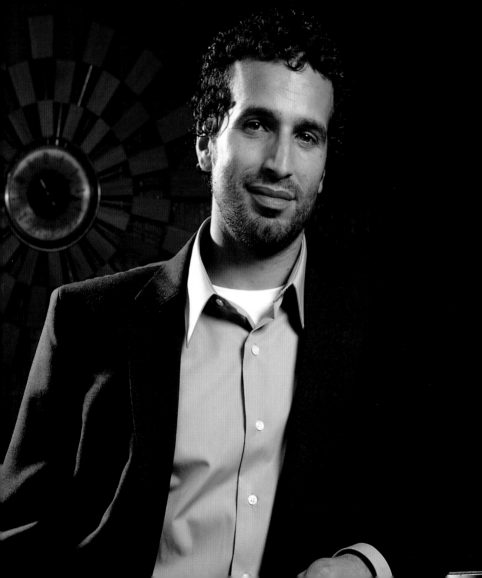

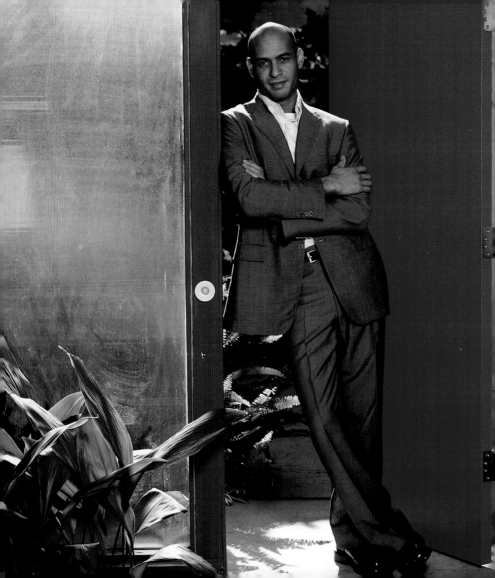

Name	MICHAEL HERNANDEZ
Age	27
Career	SUCCESSFUL ART GALLERY OWNER
Hobbies	GOURMET COOK
Last Movie Rented	THE TRUTH ABOUT CATS AND DOGS
Admire	MY MOTHER

Pornometer: How Much Are You Getting?

When you need him to listen, does he:
- A. Listen attentively, making continual eye contact?
- B. Listen for about two minutes, then start offering solutions?
- C. Watch the game over your shoulder while you're talking?

When you come home looking stressed, does he:
- A. Start a bath, light candles, make dinner, and massage your feet?
- B. Make you a nice cup of hot tea and tell you to sit down and relax?
- C. Tell you to "suck it up," then ask what's for dinner?

When you're cold, does he:
- A. Turn up the heat, even if it makes him uncomfortable?
- B. Offer to get you a sweater or blanket?
- C. Wonder aloud how you can be cold with all that body fat?

When does he bring you flowers?
- A. Often, and for no reason at all.
- B. For your birthday, anniversary, and special occasions.
- C. Only after you catch him sleeping with your sister.

After you get a haircut, how long does it take him to notice?
- A. Immediately upon seeing you.
- B. Within a few minutes.
- C. Only after asking, "Is your forehead getting bigger?"

How does he behave around your cat?
- A. Loves to sit with her on the sofa, scratching her ears and chin.
- B. Pets the cat—but only when you're looking.
- C. Views cat solely as a seat warmer.

When you mention that the bathroom needs cleaning, does he:

 A. Tell you to relax as he pulls out the cleaning supplies?

 B. Ask if it's his turn?

 C. Toss you the rubber gloves and say, "Knock yourself out, babe"?

When he cooks dinner for you, what does he make?

 A. Niman Ranch lamb tenderloin with garlic, black pepper, and Indonesian soy sauce.
 Triple chocolate decadence cake for dessert. Expensive bottle of Pinot Noir.
 Lights dimmed, candles lit.

 B. Veggie burgers, salad, and wine.

 C. Don't know. I don't recognize it as food.

If you own a minivan, does he:

 A. Drive it proudly every day, using it as an excuse to brag about his family?

 B. Grudgingly agree to drive it when asked?

 C. Tell young, single women that it belongs to his older, married brother?

When your guy uses the toilet, does he:

 A. Always lift the seat and always put it back down?

 B. Sometimes lift the seat and sometimes put it back down?

 C. Never lift the seat, splatter everywhere, and make fire truck noises?

Porn Points:

A = 3 Points B = 1 Point C = -3 Points

15 – 30 Points: Hello, sailor!

01 – 15 Points: Have your guy read this book. Twice.

-30 – 0 Points: Hopeless. Seek an immediate guy upgrade.

What makes you hot?

What can you do to make the world safe for real Porn for Women?
Share this book with a **friend**, a **sister**, or a **guy**
who's ready for enlightenment.

Tell them about your Porn for Women fantasy.
Maybe we'll hear about it and include it in a future book.
And maybe we'll send our next book out in a plain brown wrapper.
After all, this is dangerous stuff!

The Cambridge Women's Pornography Cooperative